IMAGES
*of America*

# TENNESSEE RIVER AND NORTHWEST ALABAMA

ON THE COVER: Residents and visitors, both young and old alike, enjoy fishing in the waterways of northwest Alabama. On warm days, fishermen head off to their favorite spots. From quiet pools on Cypress Creek to the banks of the Elk River, from Bear Creek Lakes in Franklin County to Wheeler Lake in Morgan and Limestone Counties, these waters are home to some of the best fishing spots in the United States. This young man, proudly displaying his catch, shows just how rich they are! (Courtesy of the Alabama Department of Archives and History.)

IMAGES
*of America*

# TENNESSEE RIVER
# AND NORTHWEST
# ALABAMA

Carolyn M. Barske and Brian Murphy

ARCADIA
PUBLISHING

Published by Arcadia Publishing
Charleston, South Carolina

Printed in the United States of America

Library of Congress Control Number: 2018937024

For all general information, please contact Arcadia Publishing:
Telephone 843-853-2070
Fax 843-853-0044
E-mail sales@arcadiapublishing.com
For customer service and orders:
Toll-Free 1-888-313-2665

Visit us on the Internet at www.arcadiapublishing.com

*This book is dedicated to the memory of Tom Hendrix, who advocated for the preservation of the Singing River and its stories.*

# CONTENTS

# ACKNOWLEDGMENTS

Many people have helped make this book a reality. Thank you to Brian Corrigan, a graduate of the University of North Alabama's master's degree program in public history and former graduate assistant in the University of North Alabama Archives and Special Collections. Corrigan helped locate images and scanned many more. He also has developed educational resource materials about the Tennessee River for the Muscle Shoals National Heritage Area for teachers in our region. Thank you also to all of the archivists who helped us locate images: Louise Huddleston, Rebekah Davis, John Allison, Victoria Antoine, Joyce Fedeczko, and Myra Borden. Thank you to the Florence Lauderdale Public Library, the University of Alabama Museums, the Library of Congress, the International Fertilizer Development Corporation, the Lawrence County Archives, the Morgan County Archives, and the Alabama Department of Archives and History for allowing us to use images from their collections. Special thanks to the Alabama Humanities Foundation for funding a companion exhibit, which, when completed, will travel to sites across the Muscle Shoals National Heritage Area (MSNHA). Thanks as well to Judy Sizemore and Cathy Wood of the MSNHA. We could not have done this without you.

While this book tells only a small portion of the story of our waterways in northwest Alabama, we hope that it shows the importance of the stewardship of the Tennessee River and its tributaries. Preserving our river helps to preserve our culture and way of life in the Muscle Shoals National Heritage Area. We thank all of those who work to keep our waters safe and beautiful.

# INTRODUCTION

The Tennessee River has played a significant role in shaping life in northwest Alabama. Beginning over 10,000 years ago, nomadic indigenous people sought the safety of rock shelters carved out of the limestone of the Highland Rim region as they came to fish the waters, hunt game, harvest plants, and gather nuts. As their settlements grew larger and more permanent, indigenous people began planting crops and building mounds. They created vast trade networks across the region and beyond, using land routes like the Natchez Trace as well as the river to travel. Problems began with European contact, first in the form of diseases contracted from Spanish explorers and then with settlers who were eager to take land from the Chickasaw and Cherokee. A series of treaties slowly eroded native control of northwest Alabama, culminating in the Indian Removal Act of 1830, which resulted in the removal of thousands of people to Indian Territory (present-day Oklahoma).

White settlers from the eastern portion of the United States who came looking for new land and opportunities noted the incredible power of the Tennessee River. They recognized how important the river would be in connecting the east with the west as the United States continued to expand. Traveling west from Florence, the river eventually connects to the Ohio River. This connection allowed goods to reach markets in the east and, via the Mississippi River, to New Orleans. The river, while full of potential, also posed some enormous challenges. Shallow rapids or shoals, rocks, and sandbars filled a roughly 80-mile stretch of the river between present-day Brown's Ferry in Limestone and Morgan County and Waterloo at the western edge of the state, making water travel slow and dangerous. The stretch between present-day Florence and Decatur was the worst, as the river also dropped over 130 feet in this 40-mile stretch. Early settlers had to figure out a way to address the navigational difficulties created by the Big and Little Muscle Shoals, the Elk River Shoals, and the Colbert Shoals (collectively known as the Muscle Shoals) so they could get their agricultural products to market.

The primary product sent out of northwest Alabama in the 19th century was cotton. One of the main motivations for farmers to come to Alabama in the early 19th century was the rich soil. While cotton production in the Highland Rim region of northwest Alabama never reached the levels it did in the Black Belt region farther south, it did make up a very significant portion of the economy. Because farming cotton was a very labor intensive enterprise, settlers brought with them slaves who broke the soil, planted and harvested the crops, and processed the cotton for sale. By 1830, slaves made up almost half of the population in Limestone and Franklin (which encompassed present-day Colbert County) Counties and a significant portion of the population of the other northwest counties. Slaves were also forced to work on engineering projects like the first Muscle Shoals Canal and the Tuscumbia, Courtland & Decatur (TC&D) Railroad.

While the first Muscle Shoals Canal failed for a multitude of reasons, including poor design and a lack of funding for maintenance, the TC&D Railroad had an enormous impact on the region. The first railroad west of the Appalachian Mountains, the TC&D Railroad started out in 1832 as a two-mile-long, horse-drawn line between Tuscumbia and Tuscumbia Landing, which residents

had built in 1824 to load cotton and other goods onto steamboats. The same year, the TC&D Railroad Company obtained its charter and started construction on a rail line around the Muscle Shoals. The first segment, completed in July 1834, reached Courtland, and the second, completed in December of the same year, reached Decatur. Steam engines replaced horses in 1836. In 1850, the railroad merged with the Memphis & Charleston Railroad. The construction of the line also resulted in the construction of railroad bridges in Florence and Decatur. During the last phases of Indian removal, Creek and Cherokee were forced off boats at Rhodes Ferry and onto the TC&D Railroad in Decatur. In Tuscumbia, they again boarded boats to travel westward.

The river played an important role in determining how the Union and Confederate forces engaged with each other in northwest Alabama during the Civil War. The forces battled over control of factories, rail lines, and bridges across the region. Both armies recognized the strategic importance of controlling the river and the railroads. Union forces almost completely destroyed the city of Decatur so they could use the wood from the buildings to construct a fort. Confederates also devastated the landscape, burning both railroad bridges that crossed the river to prevent the Union from using them. In the postwar period, the river helped the area recover economically. New businesses and factories, which used the river to move their products, brought much-needed employment to northwest Alabama.

The dawn of the 20th century brought even more drastic changes to the region. A desperate need for a reliable domestic source of nitrates for explosives during World War I led to the construction of US Nitrate Plants No. 1 and No. 2, and more importantly for the long-term vitality of the region, the Wilson Dam. While the war ended just months after construction of the dam began, the US Army Corps of Engineers continued work, completing the dam in 1925. The dam generated massive amounts of power, but with the war over, the nitrate facilities stood empty. Even before construction of the dam was complete, Henry Ford submitted a bid to buy the nitrate facilities and to lease the dam (and another to be built by the federal government) for 100 years. He proposed developing fertilizer in the facilities, producing explosives when needed during war, and using the power generated by the dam to fuel the development of an industrial corridor between Florence and Huntsville. The plan failed to gain congressional approval, as did a plan by the Alabama Power Company. Many believed the dam, paid for by taxpayer money, should be used for the public good rather than private enterprise.

When the Tennessee Valley Authority (TVA) took over Wilson Dam in 1933 and launched the construction of Wheeler and Pickwick Dams as well, it brought cheap electricity to northwest Alabama, leading to dramatic changes in the quality of life for residents of the region. It also led the country in fertilizer research and production. The TVA taught farmers better crop rotation methods and about the importance of fertilization. It worked to eradicate malaria, conducted archeological digs, opened libraries for its workers, and participated in reforestation projects, often in conjunction with other federal agencies such as the Civilian Conservation Corps and the Works Progress Administration. After World War II, during which the TVA produced explosive materials for the war effort, it also constructed coal and nuclear plants in the region.

As we move deeper into the 21st century, the Tennessee River and its tributaries continue to be instrumental in shaping the culture and industry of northwest Alabama. We fish, swim, kayak, and canoe in their waters. Barges move goods up and down the river. Corporations continue to make their homes on the river's banks. Migrating cranes and other birds stop in Wheeler Wildlife Refuge. The river continues to inspire artists and musicians who call northwest Alabama home. A growing desire to understand and appreciate the native people who lived here before us and who continue to call the region home has led to the development of museums, festivals, and educational programming. When Congress designated the Muscle Shoals National Heritage Area in 2009 to interpret, preserve, and protect the cultural, historical, and natural resources of the six counties of northwest Alabama (Colbert, Franklin, Lauderdale, Lawrence, Limestone, and Morgan), it recognized the importance and significance of the story of our region. This book only covers a small portion of this rich and powerful history. There are many, many more stories to tell. As so many people say about this area, "There's something magical in the water here." Enjoy!

# One

# Native Americans and the Tennessee River

The Tennessee River Valley has long been home to peoples who have benefitted from the rich resources found on its shores. Native people and then Euro-American settlers recognized the value of the river. This map, printed in 1886, shows the locations of early Euro-American settlements as well as native communities across what is now Tennessee, a portion of northwest Georgia, and north Alabama. Note the rendering of the Muscle Shoals, which shows the Tennessee River flowing around rocks, representing the dangerous shoals. The map also shows Cold Water Town (today Tuscumbia); a Chickasaw community, Fort Deposit; and the location of a river crossing. (Courtesy of the Library of Congress.)

During the 1930s, the Tennessee Valley Authority and the Works Progress Administration (WPA) conducted archeological digs in locations across the Tennessee River Valley. The construction of Wheeler and Pickwick Dams resulted in the river changing shape, covering evidence of Native American settlements across northwest Alabama. This image shows Bluff Creek, located in Lauderdale County on what would become Pickwick Lake. (Courtesy of the University of Alabama Museums, Tuscaloosa, Alabama.)

The digs yielded a great deal of information about the native people who lived on the banks of the Tennessee River. The evidence of the first Paleo-Indians suggests these nomadic people first arrived in the region at least 10,500 years ago. Paleo-Indians hunted game, including turkey, deer, and rabbits, and gathered plant resources, including nuts, leaves, and berries. This image shows the banks of Mulberry Creek in Colbert County. (Courtesy of the University of Alabama Museums, Tuscaloosa, Alabama.)

Paleo-Indians also relied heavily on the river for food. They ate fish they caught in rock traps or weirs built in the creeks that feed into the Tennessee River. They also hunted waterfowl and caught turtles on the banks of the river and creeks. (Courtesy of the University of North Alabama, Collier Library Archives and Special Collections.)

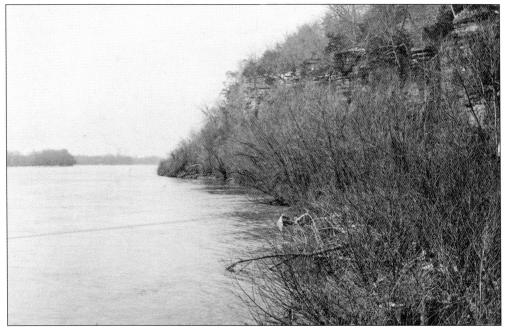

When Paleo-Indians arrived in the area, the Tennessee River looked very different than it does today. A 40-mile stretch of shoals, rapids, and sandbars made water travel between present-day Decatur and Florence very challenging. Below the Muscle Shoals west of Florence, the river grew deeper and much easier to navigate. (Courtesy of the University of North Alabama, Collier Library Archives and Special Collections.)

Paleo-Indians took advantage of rock shelters throughout northwest Alabama. When the nomadic people came through the area hunting game, they often stayed in caves, which provided safety and shelter. This cave site in Colbert County near Pickwick Lake would have also been used as a cold-weather shelter. (Courtesy of the University of Alabama Museums, Tuscaloosa, Alabama.)

Archeological evidence from caves such as this one in Morgan County allowed archeologists to determine what types of animals Paleo-Indians hunted in northwest Alabama. They also found evidence of the production of bone, wood, and antler tools. (Courtesy of the University of Alabama Museums, Tuscaloosa, Alabama.)

During the Archaic period, which lasted from 10,500 to 3,000 years ago, people living in the river valley relied on varied food sources for survival. They continued to hunt game and gather food, including hickory nuts, walnuts, and acorns. One of the largest food sources was shellfish. Archeologists have uncovered clambake ovens like this one where Archaic people cooked mussels from the river. (Courtesy of the University of Alabama Museums, Tuscaloosa, Alabama.)

While shellfish are low in nutritious value, they were easily harvested from the river and creeks. Shell middens (sites where shells from consumed shellfish were disposed) reached depths of 20 feet. Shellfish could be cooked with other foods in fire hearths like this one in Lauderdale County or they could be consumed raw. (Courtesy of the University of Alabama Museums, Tuscaloosa, Alabama.)

Shell middens, such as this one workers are shown excavating in Lauderdale County, appear in the archeological record during the middle Archaic period (8,000 to 6,000 years ago). They continued to develop into the late Archaic period (6,000 to 3,000 years ago). People close to the river may have lived on top of the mounds from May to October and moved to inland shelters

during the winter months. African American and white workers with the TVA and the WPA appear in this image. Note that the white workers are conducting the actual dig, while the African American workers wait by their wheelbarrows, ready to remove material as needed. (Courtesy of the University of Alabama Museums, Tuscaloosa, Alabama.)

This image of a mound in Morgan County shows how the TVA and WPA conducted digs. As they excavated mounds from the late Archaic period, they discovered pieces of ceramic containers and other pieces of pottery. During the late Archaic period, people also began to practice some small-scale agriculture. (Courtesy of the University of Alabama Museums, Tuscaloosa, Alabama.)

This shell midden, located in Colbert County on Pickwick Lake, shows just how massive the mounds could be. Determining the depth of the mounds required locating the base layer of shells. (Courtesy of the University of Alabama Museums, Tuscaloosa, Alabama.)

The Woodland period followed the Archaic period and lasted from 3,000 to 1,000 years ago. During this period, settlements became more permanent and the practice of agriculture expanded. Trade networks also grew, bringing mica, obsidian, and copper to northwest Alabama. This image shows the excavation of a Middle Woodland mound in Lauderdale County. (Courtesy of the University of Alabama Museums, Tuscaloosa, Alabama.)

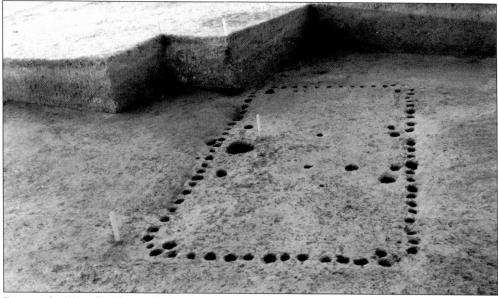

During the Woodland period, the population of northwest Alabama expanded. People began to store larger quantities of food. Bow and arrow hunting became more common, leading to more people hunting individually, rather than in groups. Woodland people also constructed permanent houses and other buildings from forest materials. These post holes show the outline of a structure from a dig in Morgan County. (Courtesy of the University of Alabama Museums, Tuscaloosa, Alabama.)

This photograph, taken in 1939 in Morgan County, shows a worker cleaning out post holes. The holes left behind after the wooden posts rotted show the shapes of structures native people built across northwestern Alabama. This image also gives an idea of the size of the structures. While it may not be known exactly how they looked when constructed in the Woodland period, one can see how buildings were laid out and how they stood in relationship to one another. (Courtesy of the University of Alabama Museums, Tuscaloosa, Alabama.)

During the Woodland period, mound building was a common occurrence across northwest Alabama. These mounds were built for ceremonial, domiciliary, and mortuary purposes. Copper and galena objects dating from the Middle Woodland period have been found in mounds across the eastern United States. This image shows the Wright Mound in Lauderdale County, which dates to the Middle Woodland period. (Courtesy of the University of Alabama Museums, Tuscaloosa, Alabama.)

The Florence Indian Mound is approximately 2,000 years old. The people who built the mound belonged to the Copena culture, part of the mound-building Hopewell tradition. Hopewell was not a single tribe but instead was groups of people connected through trade networks. The Florence Indian Mound was originally surrounded by an earthen wall and two smaller mounds, none of which survive today. (Courtesy of the University of North Alabama, Collier Library Archives and Special Collections.)

These bone atlatls were found in Lauderdale County. Atlatls were used to throw spears or darts for hunting and fighting. Bows and arrows eventually became popular tools for the same purposes. (Courtesy of the University of Alabama Museums, Tuscaloosa, Alabama.)

The Tennessee River and the creeks that feed into it are home to many fish species, including small mouth bass, crappie, and catfish. Native peoples produced fish hooks like these found in Lauderdale County from bones to take advantage of this abundant resource. This image shows the stages of the production of a fish hook from a deer toe bone. (Courtesy of the University of Alabama Museums, Tuscaloosa, Alabama.)

Archeologists found these points in a shell mound in Lauderdale County. Points were constructed using a process called knapping, which involves striking the stone to be shaped into the arrow or spearhead with a simple hammer made from stone, wood, or antler. The method used to construct the point allows archeologists to date them. People across the Muscle Shoals National Heritage Area find points around old village sites and in creek beds. Both the Oakville Indian Mounds Museum and the Florence Indian Mound Museum have large collections of points. (Courtesy of the University of Alabama Museums, Tuscaloosa, Alabama.)

The Mississippian period occurred from 1000 CE to approximately 1550 CE. During this period, communities often lived in fortified towns. They grew corn, beans, squash, and sunflowers. They continued to hunt and fish. They also built mounds and maintained trade networks. These pottery vessels discovered in Lauderdale County date from the Mississippian period. (Courtesy of the University of Alabama Museums, Tuscaloosa, Alabama.)

These tools constructed from bone were discovered in Morgan County. People would have used them for a variety of purposes. Bone could be shaped into needles, hide scrapers, awls, fish hooks, knives, and pins. (Courtesy of the University of Alabama Museums, Tuscaloosa, Alabama.)

Contact with Europeans changed life for the native people of northwest Alabama forever. The first Europeans to come to the region were Spanish. The introduction of disease by the Europeans led to the decimation of the Mississippian people. The descendants of those who survived became the Chickasaw, the Shawnee, and the Cherokee. These are Spanish coins discovered in Morgan County. (Courtesy of the University of Alabama Museums, Tuscaloosa, Alabama.)

Chickamauga Cherokee chief Doublehead established a village at the mouth of Bluewater Creek in 1790. As whites began to move into the area in the early 1800s, Doublehead began leasing land to them, an activity that neither the Cherokee nor the US government sanctioned. His own people assassinated him in 1807, furious with his actions, which they saw as a betrayal. This image shows his house near Bluewater Creek. (Courtesy of the University of North Alabama, Collier Library Archives and Special Collections.)

The Tennessee River Valley was mainly home to members of the Cherokee and Chickasaw tribes. During most of the 1700s, the Muscle Shoals served as a boundary between the two tribes, with the Cherokee living to the east and the Chickasaw living to the west. As Americans and Europeans arrived in the region, the two tribes sometimes adopted some of their ways of life. These two images show Chickasaw chief George Colbert's house, which was built in the Euro-American style. Beginning in 1798, Colbert operated a ferry across the Tennessee River. He also operated a trading post near the site of the ferry. Most, though not all, Native American people were forced out of northwest Alabama through the Indian Removal Act of 1830. The Trail of Tears crosses through northwest Alabama. (Both, courtesy of the University of North Alabama, Collier Library Archives and Special Collections.)

# *Two*

# THE TENNESSEE RIVER IN THE 19TH CENTURY

As more and more white settlers moved into northwest Alabama, they continued to be frustrated by the navigation challenges posed by the Muscle Shoals. Residents attempted to deal with the challenges in a variety of ways, including constructing the first Muscle Shoals Canal and the Tuscumbia, Courtland & Decatur Railroad in the 1830s and then through the construction of a larger Muscle Shoals Canal in the 1890s. The shoals seriously impacted development in the region in the 19th century. (Courtesy of the University of North Alabama, Collier Library Archives and Special Collections.)

In the early 1800s, flatboats and keelboats dominated river travel on the Tennessee River. A flatboat was limited in that it could only travel downstream. A keelboat could carry between 10 and 50 tons of cargo, and when poled by men on board, it could travel upstream. In 1822, the first steamboat arrived in Florence. This image shows the USS *Colbert*. (Courtesy of the University of North Alabama, Collier Library Archives and Special Collections.)

Steamboats could travel from the east to Decatur or from the west to Florence, but for most of the year they could not navigate the Muscle Shoals. The *Rocket* was one of the first steamboats to make regular trips between Florence and the Ohio River, which connected the shoals to eastern markets and to New Orleans via the Mississippi River. This image shows the USS *Lookout*. (Courtesy of the University of North Alabama, Collier Library Archives and Special Collections.)

The first attempt to go around the Muscle Shoals began in 1827 with the incorporation of the Muscle Shoals Canal Company. Congress gave land to the State of Alabama to sell in order to fund the construction of the canal. Construction began on December 1, 1830. Most of the men who worked on the project were slaves hired out by their owners. This sketch by Adolph Metzner dates from 1862 and shows a steamboat on the Tennessee River, near Florence. (Courtesy of the Library of Congress.)

By 1837, the canal was complete. The completed canal was 12 miles long and only addressed the problems posed by the Big Muscle Shoals, not the Little Muscle Shoals, Elk River Shoals, and the Colbert Shoals. The canal proved to be largely ineffective as it quickly filled with sediment, making it impossible for steamboats to travel along its length. (Courtesy of the University of North Alabama, Collier Library Archives and Special Collections.)

While getting supplies to the new settlements in the river valley was important, it was also important to get goods, the most valuable of which was cotton, out of northwest Alabama to markets in the east and to New Orleans. Grown by slaves across northwest Alabama, cotton was the source of much wealth for many white residents of the river valley. (Courtesy of the University of North Alabama, Collier Library Archives and Special Collections.)

Tuscumbia Landing was an important site for loading cotton and other goods on ships traveling west on the river. Tuscumbia was also the terminus of the TC&D Railroad, the first railroad west of the Appalachian Mountains. In 1832, the Tennessee Railroad Company constructed the first portion of the railroad, connecting Tuscumbia to the Tennessee River at Tuscumbia Landing. (Courtesy of the University of North Alabama, Collier Library Archives and Special Collections.)

The eastern terminus of the TC&D Railroad was in Decatur. Goods were offloaded from steamboats and put on the railroad. At Tuscumbia Landing, the goods were put back on steamboats. Tuscumbia Landing was also a significant site during the Trail of Tears, as the point of disembarkation for the water route used during the removal of thousands of Cherokee and Creek from the Southeast. (Courtesy of the Morgan County Archives, Decatur, Alabama.)

7. COTTON READY FOR SHIPMENT.

Growing cotton required a large labor force. While the slave population in the river valley never reached the size it would in the Black Belt region to the south, slaves still made up a significant proportion of the population. In 1830, slaves made up 32 percent of the population of Lauderdale County and 45 percent of the population in Franklin and Limestone Counties. (Courtesy of the University of North Alabama, Collier Library Archives and Special Collections.)

THE WAR IN NORTH ALABAMA—BURNING THE BRIDGE OVER THE TENNESSEE, AT DECATUR.—Sketched by Mr. H. Hübner, Third Ohio Volunteers.—[See Page 523.]

When the Civil War broke out in 1861, northwest Alabama quickly became strategically important to both Union and Confederate forces. The river was important for moving supplies and men. The Memphis & Charleston Railroad, completed in 1857, was one of the few east-west railroads in the Confederacy. Confederate forces burned the railroad bridge over the Tennessee River at Decatur in 1862. (Courtesy of the Morgan County Archives, Decatur, Alabama.)

Confederate forces burned the railroad bridge in Florence in 1862 as well. With both of the bridges destroyed, railroad travel in northwest Alabama became very challenging. This image shows the bridge pilings in Decatur after the bridge burned. (Courtesy of the Alabama Department of Archives and History.)

This sketch by Adolph Metzner shows camp doctors giving first aid to a soldier who had been bitten by a rattlesnake in Tuscumbia. Union general Alexander McDowell McCook is shown standing in the background in front of a tent. While there were no large-scale battles in northwest Alabama, Union and Confederate forces both occupied the region throughout the war. (Courtesy of the Library of Congress.)

One of the only buildings to survive the destruction of Decatur by Union troops is the Old State Bank, which was constructed in 1833. It served as a bank until 1842, when its charter was revoked. It then became a private residence. In 1934, Dr. F.Y. Cantwell purchased the building, turning it into a museum and public space. Today, it is owned by the City of Decatur. (Courtesy of the Library of Congress.)

Ferries were used to move people, animals, and their carts or wagons across the river, both before and after bridges like this one in Decatur were built. During the Creek War, part of the War of 1812, Andrew Jackson's troops had crossed the river near Florence on George Colbert's ferry. During the Civil War, ferries were used heavily after Confederate forces destroyed the bridges in Florence and Decatur. Both individuals and companies operated ferries. Passengers paid the ferry operators a fee to cross. As bridge traffic increased through the 19th century, the Tennessee River ferries slowly faded into obscurity. (Courtesy of the Alabama Department of Archives and History.)

After the Civil War, the railroad bridge over the Tennessee River in Decatur was rebuilt. Men also repaired the rail lines, and train traffic began to return to normal as the economy of north Alabama slowly recovered. (Courtesy of the University of North Alabama, Collier Library Archives and Special Collections.)

Bridge over Tennessee River, near Tuscumbia, Ala.

Opening in 1870, the railroad bridge across the Tennessee River connected Florence and Sheffield. It replaced the earlier bridge Confederate forces destroyed during the Civil War. The bridge was a combination vehicular and railroad bridge; the train and streetcars traveled along the top of the bridge, while passenger vehicles traveled underneath the tracks. (Courtesy of the University of North Alabama, Collier Library Archives and Special Collections.)

The Muscle Shoals continued to pose seriously problems after the Civil War. While the Memphis & Charleston Railroad provided an alternative to river travel, the river's navigational potential was still not realized. Unloading and loading goods from steamboats to trains took time. This image of low water on the river shows just how impossible it would be to travel by boat across the shoals. (Courtesy of the University of North Alabama, Collier Library Archives and Special Collections.)

People continued to believe that a canal could in fact be successfully constructed to circumnavigate the shoals. In 1871, Maj. Walter McFarland of the US Army Corps of Engineers came to northwest Alabama to assess the situation. This image from the early 1900s shows dredging boats working to create a channel between Florence and the Colbert Shoals. Similar boats would have been used in the late 19th century. (Courtesy of the University of North Alabama, Collier Library Archives and Special Collections.)

McFarland proposed rebuilding the old canal and constructing additional canals around the Elk River Shoals and the Little Muscle Shoals. He proposed a canal with 11 locks, which would move boats through the canal. Construction began in 1875. Initially, workers were convicts hired from prisons—a common practice in the South after the end of slavery. In 1879, the use of hired workers began when convict labor proved unsatisfactory. Construction continued through the 1880s, with no end in sight. Pictured above is a houseboat some laborers lived on while working on the river. Below is a dredger working on the river in the early 1900s. (Both, courtesy of the University of North Alabama, Collier Library Archives and Special Collections.)

In 1890, George Washington Goethals took control of the canal project. Goethals was born in Brooklyn in 1858. He attended the College of the City of New York before being appointed to the US Military Academy at West Point. He graduated in 1880. He then attended engineering school. This image shows the construction of Lock 4 from the upper end. (Courtesy of the University of North Alabama, Collier Library Archives and Special Collections.)

When he arrived in northwest Alabama in August 1890, Goethals faced enormous pressure to get the canal running as soon as possible. He put workers on day and night shifts to help move the project to completion quickly. This image shows Section 9 of the canal. (Courtesy of the University of North Alabama, Collier Library Archives and Special Collections.)

During his oversight of the construction of the canal, Goethals built a 14-mile-long railroad to help speed up the building of the canal. This image shows a riverboat locking through on the canal. (Courtesy of the Alabama Department of Archives and History.)

The Muscle Shoals Canal opened just four months after Goethals arrived in northwest Alabama. The first boat to travel the length of the canal was the *R.T. Cole*, which was headed to Chattanooga with a load of grain. The total cost of the construction of the Muscle Shoals Canal was $3,191,726.50. This image shows one of the locks on the eastern end of the canal. (Courtesy of the Lawrence County Archives, Moulton, Alabama.)

A steamboat full of workers from the Ashcraft Cotton Mill is pictured moving through the canal. The mill opened as a cotton oil refinery in 1898, then called the Florence Cotton Oil Company. Initially, the company employed between 50 and 75 workers. In 1899, the Ashcrafts decided to switch from refining cotton oil to producing cotton textiles. Located in the Sweetwater area of Florence, the mill had over 3,600 spindles and 100 looms, making it one of the largest cotton mills in Lauderdale County. The Ashcraft Cotton Mill became the Florence Cotton Mill in 1927. It remained open through the Great Depression and World War II, eventually closing its doors like many other US textile mills in the postwar era. (Courtesy of the University of North Alabama, Collier Library Archives and Special Collections.)

After the completion of the Muscle Shoals Canal, the US Army Corps of Engineers gave Goethals oversight of all improvement projects on the river between Chattanooga and Florence. Goethals made his headquarters in Florence. From there, he could monitor the canal and make sure necessary maintenance took place so steamboats like this one could move through the canal with as few problems as possible. (Courtesy of the Lawrence County Archives, Moulton, Alabama.)

Goethals also monitored the railroad that traveled next to the canal, shown here crossing the aqueduct at Shoal Creek in Florence. (Courtesy of the Alabama Department of Archives and History.)

The railroad's proximity to the canal is shown in this photograph of Lock 4, looking up the canal. Each lock on the canal was 60 feet wide by 284 feet long. (Courtesy of the University of North Alabama, Collier Library Archives and Special Collections.)

The lifts of locks on the canal ranged in depth from 0 feet at Lock 1 to 13.14 feet at Lock 6. A total of nine locks allowed boats to navigate across the Muscle Shoals. This image shows a steamboat at the Shoal Creek Aqueduct. (Courtesy of the University of North Alabama, Collier Library Archives and Special Collections.)

Goethals oversaw a machine shop, blacksmith shop, stable, and an iron foundry in Florence for the maintenance of the canal. He also ensured that the telegraph lines were in working order. A shipyard and dry dock in Florence helped to maintain towboats and barges like those pictured here. (Courtesy of the University of North Alabama, Collier Library Archives and Special Collections.)

The Riverton Lock, pictured here, was part of the Colbert Shoals Canal. The Colbert Shoals were less of an impediment to travel than the Muscle Shoals, but during low water, they could be difficult to navigate. Most of the community of Riverton was flooded with the construction of Pickwick Dam. (Courtesy of the University of North Alabama, Collier Library Archives and Special Collections.)

LOCK 8, MUSCLE SHOALS CANAL.    AQUEDUCT, MUSCLE SHOALS CANAL, NEAR FLORENCE, ALA.

The construction of the Colbert Shoals Canal began in 1891. For the canal, Goethals designed a 26-foot lock, the largest lock ever constructed at the time. Lock 8 on the Muscle Shoals Canal, shown here, was only 9.88 feet. (Courtesy of the University of North Alabama, Collier Library Archives and Special Collections.)

Goethals left northwest Alabama in 1894 for an appointment as an assistant to the chief of engineers in the Army Engineering Department in Washington, DC. After the Spanish-American War, he taught at West Point before supervising the construction of seacoast defenses from Newport, Rhode Island. He went on to oversee the construction of the Panama Canal in the 20th century. (Courtesy of the University of North Alabama, Collier Library Archives and Special Collections.)

While the canal made travel on the Tennessee River easier, the river still had not been tamed. Flooding continued to be a problem, and travel often still remained challenging. Work in the early 1900s included creating a channel between Florence and Colbert Shoals and another below Riverton. This image shows Lock 9 on the canal. (Courtesy of the University of North Alabama, Collier Library Archives and Special Collections.)

The canal helped create jobs for residents along its banks. Men were hired to operate the locks, managing the water traffic as it moved up and down the river. This image from the William Lindsey McDonald Collection at the University of North Alabama shows men working on a lock on the canal. (Courtesy of the University of North Alabama, Collier Library Archives and Special Collections.)

43

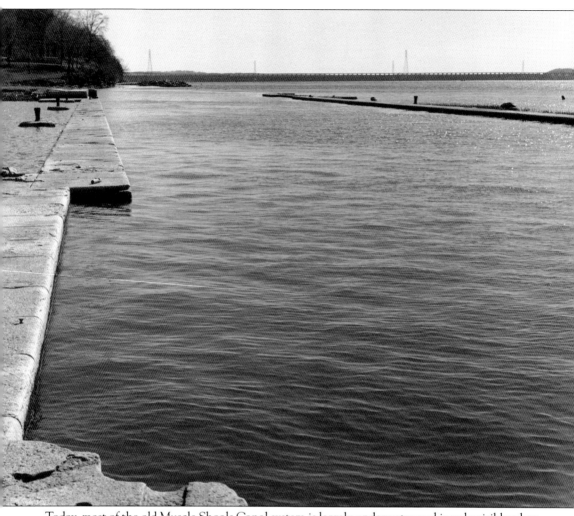

Today, most of the old Muscle Shoals Canal system is largely underwater and is only visible when the water is very low. After the Wheeler, Wilson, and Pickwick Dams were constructed, the canal system was no longer necessary. This image shows Lock 3, which was located at the confluence of the Tennessee River and Blue Water Creek. Wheeler Dam is visible in the background. While the Muscle Shoals Canal certainly helped address the problem of the shoals, the dams would finally solve it. (Courtesy of the University of North Alabama, Collier Library Archives and Special Collections.)

# Three

# WORLD WAR I, THE WILSON DAM, AND NITRATE FACILITIES

When the US government made the decision to build a hydroelectric dam at the Muscle Shoals, life in northwest Alabama changed forever. For a century, travel and economic development in the region had been shaped by the challenges the shoals presented. With the construction of Wilson Dam, growth could occur more freely as goods and people could travel a greater portion of the river much more easily. This 1924 map shows the planned development of the city of Muscle Shoals, which did not exist prior to the construction of the dam and the nitrate facilities it powered. (Courtesy of the University of North Alabama, Collier Library Archives and Special Collections.)

The construction of Wilson Dam involved creating an inspection and observation tunnel running through the spillway and powerhouse sections. In a 1922 report discussing progress on the construction of the dam, Hugh L. Cooper, the consulting engineer, discussed the difficulty of creating a stable foundation on a stratified rock foundation, rather than on a much more secure granite foundation. Cooper believed a stable foundation could be created but that the process required "a much more experienced handling." (Both, courtesy of the University of North Alabama, Collier Library Archives and Special Collections.)

This image from 1924 shows another view of the tunnel underneath the Wilson Dam. The tunnel measures six feet by nine feet. The elevation of the tunnel floor sits at 411 feet, 137 feet below the elevation of Florence. (Courtesy of the University of North Alabama, Collier Library Archives and Special Collections.)

The story of the Wilson Dam began in 1824 when, in *Gibbons v. Ogden*, the Supreme Court ruled that waterways in the United States were public. This meant private corporations or individuals could not control creeks, rivers, lakes, and other bodies of water for personal gain. This image shows the early phases of the construction of Wilson Dam by the US Army Corps of Engineers. (Courtesy of the University of North Alabama, Collier Library Archives and Special Collections.)

When settlers arrived in northwest Alabama, they immediately recognized the potential power of the river at the Muscle Shoals. In the 1880s, the first hydroelectric stations commenced operation in the United States, generating power to operate a new invention by Thomas Edison: the incandescent lightbulb. This image also shows the early phases of construction of the dam. (Courtesy of the University of North Alabama, Collier Library Archives and Special Collections.)

In 1897, a group of investors interested in hydroelectric power generation formed the Muscle Shoals Power Company (MSPC). The MSPC requested Congress's permission to construct a hydroelectric power plant on the Tennessee River. As this image shows, construction of the dam involved building wooden frames and pouring concrete into these frames. (Courtesy of the University of North Alabama, Collier Library Archives and Special Collections.)

Lawrence County resident Gen. Joe Wheeler introduced a bill in the House of Representatives in 1898 to give the MSPC permission for its project. Here, river traffic can be seen continuing on the canal to the north of the dam. (Courtesy of the University of North Alabama, Collier Library Archives and Special Collections.)

Congress approved the bill in 1899, but as the MSPC was a private entity, the secretary of war (who had oversight over navigable waterways) could charge a fee for the use of the water necessary for generating hydroelectric power. The MSPC did not proceed with its plans because of the cost of paying for the water. (Courtesy of the University of North Alabama, Collier Library Archives and Special Collections.)

Other companies also requested permission for similar projects. Pres. Teddy Roosevelt refused to grant N.F. Thompson and Associates permission to construct a dam. Another proposal, a joint project between the Muscle Shoals Hydro-Electric Power Company and the US Army Corps of Engineers, also failed. Here, the Wilson Dam spillways are taking shape. (Courtesy of the University of North Alabama, Collier Library Archives and Special Collections.)

When World War I began, the US government was very concerned about the safety of Chilean shipments of bat guano, from which nitrates for explosives were derived, to the United States. Two new processes, known as the Haber and Cyanamid, produced nitrates in factories. Two nitrate producing facilities were built in Muscle Shoals, along with a hydroelectric dam (pictured) to provide them with power. (Courtesy of the University of North Alabama, Collier Library Archives and Special Collections.)

In 1916, Congress passed the National Defense Act, which provided for the construction of two nitrate plants and a hydroelectric facility to power them. The Muscle Shoals Association advocated for the construction of the facilities on the Tennessee River in northwest Alabama. This image gives a closer look at the construction of wooden forms for concrete. (Courtesy of the University of North Alabama, Collier Library Archives and Special Collections.)

On September 28, 1917, President Wilson's decision to construct the two nitrate facilities in Sheffield, Alabama, was made public. The government then authorized the construction of a dam to supply power to the plants on February 23, 1918. (Courtesy of the University of North Alabama, Collier Library Archives and Special Collections.)

In 1918, President Wilson approved a budget of $12 million for the construction of the dam. The US Army Corps of Engineers oversaw construction, which began in May 1918, just six months before the end of World War I. Constructing the dam was a complicated endeavor, as seen here. (Courtesy of the University of North Alabama, Collier Library Archives and Special Collections.)

Despite the war's end, construction of the dam continued. The dam, an overflow masonry weir dam, required massive amounts of concrete for its construction. In the end, 1.35 million cubic yards of concrete were used. This image shows a crane preparing to lift a spillway gate into place. (Courtesy of the University of North Alabama, Collier Library Archives and Special Collections.)

In March 1918, Col. Hugh Lincoln Cooper was brought from his base in France to Muscle Shoals to oversee construction of the project. Cooper's first time in Muscle Shoals was short; he was ordered back to France in May 1918. Eventually, in 1920, Cooper returned to the project as an unsalaried chief construction engineer. (Courtesy of the University of North Alabama, Collier Library Archives and Special Collections.)

Concrete for the dam was mixed at the Jackson Island mixing plant. In 1920, a fire destroyed the plant. New mixers were brought in from Nashville. This image shows how the work surface on the top of the dam utilized both a rail system and cranes to move elements into place. (Courtesy of the University of North Alabama, Collier Library Archives and Special Collections.)

Construction on the dam continued into 1921, when work halted because of a lack of funds. At the time, the dam was 35 percent completed. Men who had been working on the dam lost their jobs when the project stopped. (Courtesy of the University of North Alabama, Collier Library Archives and Special Collections.)

Work on the dam resumed in 1922, funded by a congressional appropriation of $7.5 million. Over 4,000 workers returned to the site as construction began anew. These men helped to bolster the economy of the Muscle Shoals region as they purchased supplies and sought out entertainment in Florence, Sheffield, and Tuscumbia. (Courtesy of the University of North Alabama, Collier Library Archives and Special Collections.)

This photograph, taken on January 27, 1924, shows the upstream, or east, face of the spillway section. It was taken from Jackson Island. Today, the island is submerged. (Courtesy of the University of North Alabama, Collier Library Archives and Special Collections.)

To make the concrete for the dam, men dredged sand and gravel from the riverbed 12 miles to the west of the dam. After it had been cleaned, the material was brought to the construction site and mixed on Jackson Island. This photograph from December 31, 1925, shows the removal of construction bridge piers in the sluiceway section. (Courtesy of the University of North Alabama, Collier Library Archives and Special Collections.)

From 1922 to 1925, when the dam was completed, work continued at a rapid pace. This aerial view shows all of the work happening on the top of the dam as well as at the base of the dam. Additionally, it gives an idea of the network of support buildings and housing that grew up on either side of the river. (Courtesy of the University of North Alabama, Collier Library Archives and Special Collections.)

This photograph of the spillway section of Wilson Dam, taken on November 3, 1924, shows the last arch being poured for the roadway across the top of the dam. Still open today, the roadway connects the north and south ends of the dam. (Courtesy of the University of North Alabama, Collier Library Archives and Special Collections.)

The construction of the powerhouse took place at the same time as the dam. Pictured is the west face of the dam, still under construction, as well as the powerhouse, which is located on the south bank of the river. (Courtesy of the University of North Alabama, Collier Library Archives and Special Collections.)

This view from the west side of the dam before the sluiceways opened gives some perspective of the size of the dam. Stretching 137 feet tall and 160 feet wide at the base, including the apron (shown here), the dam was truly an impressive site. (Courtesy of the University of North Alabama, Collier Library Archives and Special Collections.)

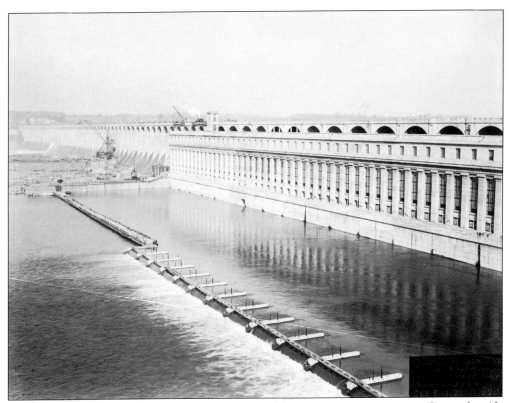

The powerhouse, shown here on December 31, 1925, began generating power on September 12, 1925. One of the largest questions that remained unanswered as construction came to a close was what this power would be used for. Taxpayer money had paid for the dam, so many believed the purpose must be for the common good of the people. (Courtesy of the University of North Alabama, Collier Library Archives and Special Collections.)

As construction wound down, most of the cranes and the railroad line were removed and the top of the dam covered in concrete to allow vehicles to cross over the river via the dam. (Courtesy of the University of North Alabama, Collier Library Archives and Special Collections.)

This photograph from April 9, 1926, shows some of the spillways open and loose rock washed below the dam apron. Though the dam was completed by this point, two cranes still sat atop the dam to support the generating facilities in the powerhouse. (Courtesy of the University of North Alabama, Collier Library Archives and Special Collections.)

This picture shows Wilson Dam with 33 of the original 49 spillway gates open, generating hydroelectric power. The spillways are open four feet, six inches. The picture was taken on May 22, 1926. (Courtesy of the University of North Alabama, Collier Library Archives and Special Collections.)

In 1926, when this photograph of the lower south guard wall was taken, the dam was operational. The lock, however, which allowed boats to move freely to the east and west of the dam, was not yet complete. (Courtesy of the University of North Alabama, Collier Library Archives and Special Collections.)

On the upper side of the dam, the water is 97.6 feet deep, which means that in order for water traffic to travel from one side of the dam to the other, a lock system had to be constructed to move traffic. This photograph, taken on January 5, 1926, shows the excavation of the approach to the lower lock. (Courtesy of the University of North Alabama, Collier Library Archives and Special Collections.)

In order to deal with the immense drop from the east side of the dam to the west side, the US Army Corps of Engineers constructed a two-chambered lock. The upper chamber of the lock measured 60 feet by 292 feet. The lower chamber measured 60 feet by 300 feet. Combined, the two locks had a lift of 90 feet. (Courtesy of the University of North Alabama, Collier Library Archives and Special Collections.)

Hydroelectric power changed how lock systems across the country operated. The gates of the Wilson Dam locks operated electronically, unlike the gates on the Muscle Shoals Canal. (Courtesy of the University of North Alabama, Collier Library Archives and Special Collections.)

The two-chambered lock remained in operation until 1959, when a single-chamber lock opened. When completed, this lock was the largest single-chamber lock in the world. It measures 110 feet by 600 feet, with a maximum lift of 100 feet, the largest lock east of the Rocky Mountains. The two original locks remain as an auxiliary system. (Courtesy of the University of North Alabama, Collier Library Archives and Special Collections.)

A 148-foot lift bridge allowed traffic to move over the locks. Pictured is the upper end of Lock 2. The lift bridge is raised to allow the first boats to pass on March 5, 1926. (Courtesy of the University of North Alabama, Collier Library Archives and Special Collections.)

The first two vessels to pass under the bridge and through the locks were the steamer *U.S. McPherson*, of Florence, Alabama, and the dredge *Kwasind*. (Courtesy of the University of North Alabama, Collier Library Archives and Special Collections.)

Large crowds gathered to watch the exciting moment. Here, the two vessels have entered into the upper lock. (Courtesy of the University of North Alabama, Collier Library Archives and Special Collections.)

WILSON DAM, TENN RIVER
Str McPherson & Dredge
Kwasind in upper chamber
Lock 2 Lower Level

As the water level decreased in Lock 2, the upper lock, the steamer *U.S. McPherson* and dredge *Kwasind* moved slowly to the water level of Lock 2. Total locking time averaged about an hour. Today, with the single-chamber lock, boats and barges lock through on average in about 45 minutes. Watching the lock operate was a popular pastime in Florence until September 11, 2001, when public access to the locks ended for security reasons. Today, the lock is once again open to the public on Fridays, Saturdays, Sundays, and federal holidays from 7:00 a.m. to 7:00 p.m. (Both, courtesy of the University of North Alabama, Collier Library Archives and Special Collections.)

DAM #1, TENN.RIVER,
Elect. driven pump
for hydraulic oper-
ation of lock mach.
April 5, 1926. #101

This is the electricity-driven pump for hydraulic operation of the locking system. Without the ability to use electrical power to operate the locks, the development of such a massive locking system would have been impossible. (Courtesy of the University of North Alabama, Collier Library Archives and Special Collections.)

Official Photographs — U.S. Engineer Office
Florence Ala.

WILSON DAM, TENN RIVER
FLORENCE, ALA.
30,000 H.P. HYDRAULIC
TURBINES
EFFECTIVE HEAD 95 FEET
SPEED 100 R.P.M.

While the dam and the lock system certainly improved travel on the Tennessee River, the dam was also built to generate electricity. In order to do so, the US Engineer's office had to design turbines. This drawing shows a 30,000-horsepower hydraulic turbine designed for Wilson Dam. (Courtesy of the University of North Alabama, Collier Library Archives and Special Collections.)

The turbines installed in Wilson Dam are rotary engines. They convert the energy of the water moving through the dam into mechanical energy. This image shows the construction of a turbine in the Wilson Dam powerhouse. (Courtesy of the University of North Alabama, Collier Library Archives and Special Collections.)

Once the turbines have turned the energy of the water into mechanical energy, the mechanical energy then moves through the drive shaft and operates generators. (Courtesy of the University of North Alabama, Collier Library Archives and Special Collections.)

The Wilson Dam powerhouse, built out of concrete to house the turbines, measures 1,200 feet in length, 71 feet in width, and is 134 feet high. (Courtesy of the University of North Alabama, Collier Library Archives and Special Collections.)

Initially, the US Army Corps of Engineers installed eight hydraulic turbines and generating units. The TVA installed another 10 units in the Wilson Dam powerhouse between 1940 and 1950. This gave the Wilson Dam powerhouse the capability to produce 436,000 kilowatts of energy. (Courtesy of the University of North Alabama, Collier Library Archives and Special Collections.)

The view from the Wilson Dam has long attracted spectators interested in seeing the river pour through the gates. When the dam first opened, there were 49 spillway gates. Today, there are 58. Each gate can discharge 10,000 cubic feet per second. When the gates are open after a heavy rain, it is quite a spectacle. (Courtesy of the University of North Alabama, Collier Library Archives and Special Collections.)

This image by a photographer with the Historic American Engineering Record shows the dam with all spillways closed. In the background is the powerhouse on the Muscle Shoals side of the dam. Visible in the foreground is the roadway that was built over the single-chamber lock to replace the lift gate. (Courtesy of the Library of Congress.)

This aerial view of the Wilson Dam looking northeast shows the huge span of the dam. Wilson Dam is the only Neoclassical dam in the Tennessee Valley Authority system. It is also the largest conventional hydroelectric facility in the TVA system, generating more power than all other TVA dams, with the exception of the Raccoon Mountain Pumped-Storage Facility near Chattanooga, which is not a traditional hydroelectric system. (Courtesy of the Alabama Department of Archives and History.)

Another aerial view of the dam and Wilson Reservoir, this photograph was taken looking southwest. The creation of the reservoir changed the shape of the river above and below the dam. It also resulted in the permanent flooding of some areas. Wilson Reservoir has 166 miles of shoreline and 15,500 acres of water surface. It holds 208.3 billion gallons of water. The reservoir is known as the "Smallmouth Capital of the World." On average, 3,700 boats and other vessels lock through the Wilson Dam each year. (Courtesy of the University of North Alabama, Collier Library Archives and Special Collections.)

An estimated 56 men died during the construction of the dam, many in railroad accidents. Others fell to their death or drowned. Still others were killed when they were struck by concrete buckets, chains, and rocks. This monument was constructed in their memory. (Courtesy of the University of North Alabama, Collier Library Archives and Special Collections.)

These are some of the men who worked with the US Army Corps of Engineers to construct the dam between 1918 and 1925. The men were divided into two divisions. One division worked on the construction of the dam and lock. The other division worked on the construction of the powerhouse. (Courtesy of the University of North Alabama, Collier Library Archives and Special Collections.)

Both black and white laborers worked to build the Wilson Dam. African Americans were relegated to lower-paying jobs and had few opportunities for advancement, both in terms of responsibility and earnings, a pattern that would continue when the TVA came to the valley in the 1930s. (Courtesy of the University of North Alabama, Collier Library Archives and Special Collections.)

The major motivation for the construction of the Wilson Dam was to generate power for two nitrate facilities. Completed in 1925, and with no real need for nitrate production, the plants and Wilson Dam remained in limbo as the government debated what to do with its massive investment. Pictured is construction of the Autoclave Building at US Nitrate Plant No. 2 in Muscle Shoals. (Courtesy of the University of North Alabama, Collier Library Archives and Special Collections.)

The National Defense Act of 1916 "authorized and empowered [the president] to make, or cause to be made, such investigation as his judgment is necessary to determine the best, cheapest, and most available means for the production of nitrates and other products for munitions of war." This image shows white and black workers building the powerhouse for US Nitrate Plant No. 2 on April 23, 1918. (Courtesy of the University of North Alabama, Collier Library Archives and Special Collections.)

Additionally, the act allowed the president to consider the production of nitrates for fertilizer. Congress appropriated $20 million to achieve the goals of the National Defense Act. This image shows the interior of the woodworking shop at US Nitrate Plant No. 2. (Courtesy of the University of North Alabama, Collier Library Archives and Special Collections.)

In order to determine the best procedure to follow during the implementation of the act, the president formed the Interdepartmental Nitrates Board. Members of the board included the secretaries of war, agriculture, and the interior. Scientists and businessmen served on board subcommittees. Pictured is construction of the mess halls at US Nitrate Plant No. 2. (Courtesy of the University of North Alabama, Collier Library Archives and Special Collections.)

The committee recommended two processes. The first, the Haber process, was used at US Nitrate Plant No. 1 and was never successful. The second, the Cyanamid process, was used at US Nitrate Plant No. 2. Pictured here are men constructing the powerhouse for the Cyanamid plant using mules, trains, and cranes. (Courtesy of the University of North Alabama, Collier Library Archives and Special Collections.)

The Haber process, which was the German process for producing nitrates, had been modified by the General Chemical Company. Only preliminary work on the modified method had been completed when construction of US Nitrate Plant No. 1 began. This image shows the absorption towers under construction at US Nitrate Plant No. 2 on January 9, 1919. (Courtesy of the University of North Alabama, Collier Library Archives and Special Collections.)

The Cyanamid method, while more expensive and requiring much more power to achieve results, had already been proven successful by companies in the United States. Pictured is Ravine 3 at the US Nitrate Plant No. 2 powerhouse site on February 28, 1918. (Courtesy of the University of North Alabama, Collier Library Archives and Special Collections.)

The War Department entered into a contract with the American Cyanamid Company and its subsidiary, the Air Nitrate Corporation, to build a plant. To house employees, workers also constructed two villages. This image shows the laying out of streets and house sites for Nitrate Village No. 2. The sign on the left reads "IF YOU WANT TO BEAT THE KAISER WORK DON'T LOAF." (Courtesy of the University of North Alabama, Collier Library Archives and Special Collections.)

This is the same street corner in Nitrate Village No. 2 as in the previous image, fewer than three weeks later. The first image was taken on May 6, 1918, and the second was taken on May 23, 1918, both at the corner of Alabama and Filbert Streets. (Courtesy of the University of North Alabama, Collier Library Archives and Special Collections.)

In the era of segregation, white and black workers had separate communities in the villages. This photograph, taken on May 6, 1918, shows the construction of housing for the African American workers and their families at US Nitrate Plant No. 2. (Courtesy of the University of North Alabama, Collier Library Archives and Special Collections.)

This is another block of housing in the African American village at Nitrate Village No. 2. Housing for African American workers was smaller and lacked many of the amenities found in the white housing. (Courtesy of the University of North Alabama, Collier Library Archives and Special Collections.)

This final image of African American housing at Nitrate Village No. 2 has an interesting (though for the time, typical) feature. Because dirt roads quickly became quite muddy and difficult to navigate in the wet Alabama climate, this neighborhood has wooden sidewalks so that residents could avoid the mud. (Courtesy of the University of North Alabama, Collier Library Archives and Special Collections.)

When this photograph was taken in 1919, World War I was over. While construction of the villages and the nitrate facilities was largely complete, the communities quickly emptied out when the plants shut down. (Courtesy of the University of North Alabama, Collier Library Archives and Special Collections.)

This April 10, 1919, photograph of Greenbriar Street in Nitrate Village No. 2 shows the amenities some white village residents enjoyed, including a trolley line. Note that wooden sidewalks were constructed in this community as well. (Courtesy of the University of North Alabama, Collier Library Archives and Special Collections.)

Pictured is construction of ordnance barracks near Block R in Nitrate Village No. 2. (Courtesy of the University of North Alabama, Collier Library Archives and Special Collections.)

To supply US Nitrate Plant No. 2 with limestone, which is necessary for the production of nitrates, a quarry opened in Russellville, Alabama, about 20 miles south of Sheffield. This image from August 26, 1918, shows the tent colony for workers at the quarry. (Courtesy of the University of North Alabama, Collier Library Archives and Special Collections.)

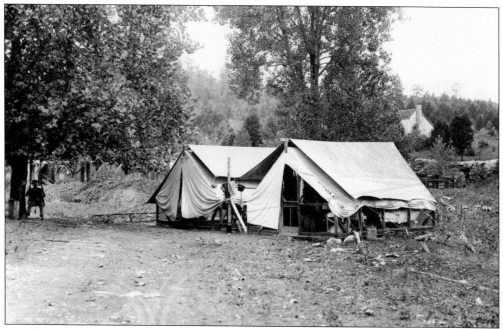

Another image of the tent colony at the Rockwood Quarries in Russellville from August 26, 1918, shows that life in the colony did allow for some downtime, despite the pressing need for limestone. Note the man on the swing under the tree at left. (Courtesy of the University of North Alabama, Collier Library Archives and Special Collections.)

The consulting engineer's office at Rockwood Quarries was a bit more permanent than the tents workers lived in. (Courtesy of the University of North Alabama, Collier Library Archives and Special Collections.)

LIBERTY BELL SHAPED RESIDENTIAL SECTION FOR GOVERNMENT EMPLOYEES, MUSCLE SHOALS, ALA.

Like Nitrate Village No. 2, Nitrate Village No. 1 was located in Sheffield. Built between May 1918 and May 1919, Nitrate Village No. 1 was laid out in a "liberty bell" shape, with two large greens. Both military and civilian personnel who worked at US Nitrate Plant No. 1 resided in the village. (Courtesy of the University of North Alabama, Collier Library Archives and Special Collections.)

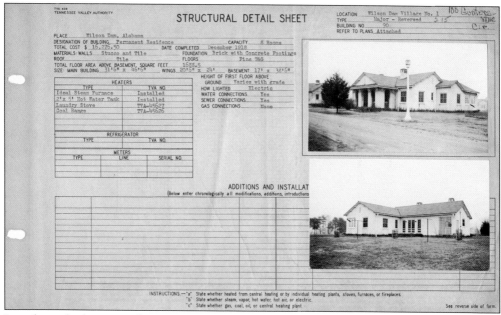

In order to facilitate speedy construction, the architectural firm Ewen and Allen developed just 12 different designs for homes. This structural detail sheet shows one of the designs for an officer's house. Construction of this design cost $16,276.50. Like all houses in the village, this one was constructed of brick with concrete footings, coated in stucco, and had a hollow tile roof. (Courtesy of the University of North Alabama, Collier Library Archives and Special Collections.)

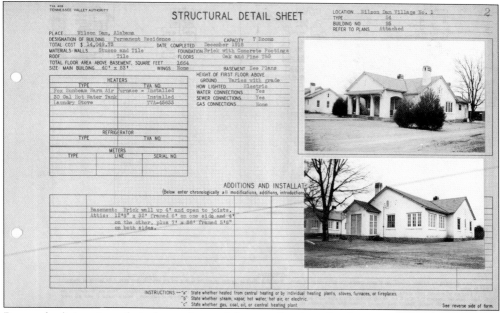

By standardizing sizes of window sashes and doors and making hardware and fixtures simple and as uniform as possible, the architects made construction much easier. Some elements of the houses were also prefabricated and delivered to the village. This structural detail sheet shows a different design for another officer's house. (Courtesy of the University of North Alabama, Collier Library Archives and Special Collections.)

When work at US Nitrate Plant No. 1 ceased in 1919, the houses, officer's barracks, the school, and other buildings had barely been lived in or used. They remained largely empty until the establishment of the TVA in 1933. Along with the village school, the officer's barracks, pictured here, operated as educational facilities for the children of residents of the village. (Courtesy of the University of North Alabama, Collier Library Archives and Special Collections.)

In 1949, the TVA made the decision to deed the public portions of the village to the City of Sheffield, including the streets, schools, and playgrounds. It then auctioned off homes like the one shown in this blueprint. (Courtesy of the University of North Alabama, Collier Library Archives and Special Collections.)

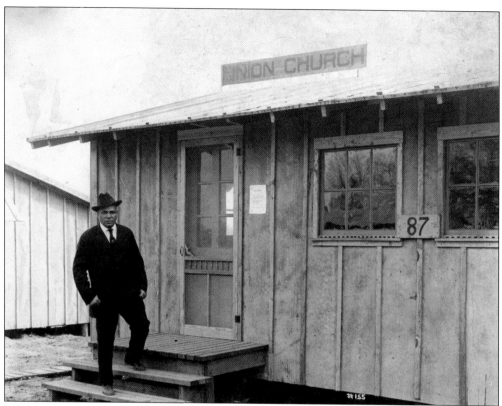

While some residents likely worshipped at churches in Sheffield, others attended services in the village communities. This is the African American Union Church, located in Nitrate Village No. 2. (Courtesy of the University of North Alabama, Collier Library Archives and Special Collections.)

Payday was one of the busiest days at the nitrate facilities. The money that men made working at the plants and on the dam helped to spur economic growth in the surrounding communities of Florence, Sheffield, and Tuscumbia. (Courtesy of the University of North Alabama, Collier Library Archives and Special Collections.)

To help feed the men who worked at the plants, farm workers grew crops and raised animals like these hogs, shown during feeding time. (Courtesy of the University of North Alabama, Collier Library Archives and Special Collections.)

This delegation was visiting the nitrate facilities. Perhaps the more interesting part of this image, however, are all the signs with rules the workers had to follow regarding overtime and work hours. (Courtesy of the University of North Alabama, Collier Library Archives and Special Collections.)

*Four*

# THE TENNESSEE VALLEY AUTHORITY

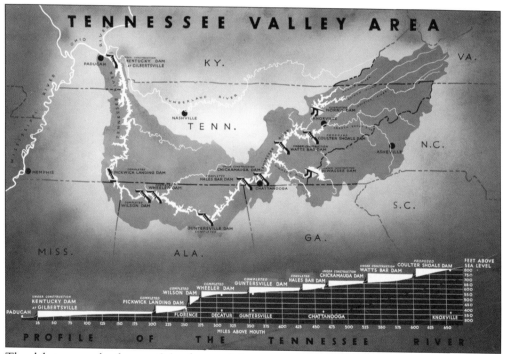

The debate over the future of the dam and the nitrate facilities stretched on for over 10 years. In the midst of the debate, the Great Depression struck. Even before the Depression began, the Tennessee River Valley was one of the poorest regions in the nation. Many residents were illiterate, and the birthrate was one third higher than that of the rest of the nation. Only three percent of farms had running water, and per capita income was half of the national average. The TVA, with its system of dams that generated power and reduced flooding, changed life dramatically. It also produced fertilizer and taught farmers better farming practices that improved the health of their soil. The TVA also worked to eradicate malaria, an enormous public health problem in the region. (Courtesy of the Alabama Department of Archives and History.)

In January 1933, two months before he took office as president, Franklin Delano Roosevelt visited the shoals to inspect Wilson Dam. Roosevelt traveled with Senator Norris of Nebraska. Norris had long fought to ensure that Wilson Dam, which had been paid for with taxpayer money, would generate power for the good of the American people, rather than for private interests. Congress had rejected proposals for leasing the dam for power generation from Henry Ford and others. This image shows the crowds in Sheffield waiting to catch a glimpse of the president-elect when he visited the town. (Courtesy of the University of North Alabama, Collier Library Archives and Special Collections.)

President Elect
Roosevelt
Wilson Dam

In a speech in Montgomery on January 21, Roosevelt highlighted the significance of the dam and the role it would play in the country moving forward: "Muscle Shoals is more than an opportunity to do a good turn for the people of one or two states. It can do a great deal for the people of many states, and the whole country by tying industry, agriculture, forestry and flood control into one great development and so afford a better place for millions yet unborn in the days to come." (Courtesy of the Florence Lauderdale Public Library Digital Archive.)

The Muscle Shoals Act of May 18, 1933, created the TVA "for the purpose of maintaining and operating the properties now owned by the United States in the vicinity of Muscle Shoals, Alabama, in the interest of national defense and for agricultural and industrial development." This image shows TVA director David Lilienthal standing at the base of the Wilson Dam. (Courtesy of the Alabama Department of Archives and History.)

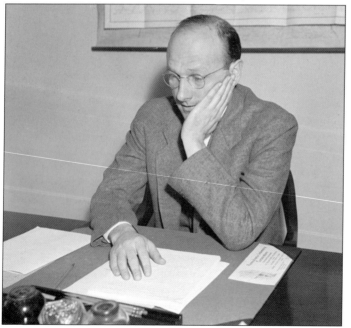

The other two men who joined Lilienthal (shown here) in leading the TVA were Dr. Harecourt Morgan and Arthur Morgan. Lilienthal was an attorney from Wisconsin who supported utility regulation, Harecourt Morgan was the president of the University of Tennessee, and Arthur Morgan was an engineer and community organizer. (Courtesy of the Library of Congress.)

In addition to generating power, the TVA's agricultural division worked to teach farmers about terracing, fertilizers, and crop rotation to improve the output of farms in the Tennessee River Valley. The division also advocated the planting of legumes to fix nitrogen in the soil and removing poor lands from cultivation. Dr. Harecourt Morgan (left) is pictured with David Lilienthal. (Courtesy of the Library of Congress.)

The TVA faced internal issues early on. David Lilienthal is pictured trying to catch Arthur Morgan's every word before the congressional TVA investigating committee in 1938. That year, Roosevelt removed Arthur Morgan from the chairman's position, replacing him with Harecourt Morgan. Disagreements over policy and the role of the TVA in the region between Lilienthal and Arthur Morgan led to FDR's decision. (Courtesy of the Library of Congress.)

Even before the formation of the TVA, Congress had appropriated $30 million through the Emergency Relief and Construction Act for river and harbor projects. Some of the money went to the construction of a dam and lock above the Wilson Dam, which became the Wheeler Dam. Work on the Wheeler Dam began on November 21, 1933, under the oversight of the TVA. The Wheeler Dam is longer than the Wilson Dam, measuring 6,352 feet in length. It is, however, shorter in height, at 72 feet. (Courtesy of the Alabama Department of Archives and Special Collections.)

Like most dam projects on the Tennessee River, the construction of Wheeler Dam resulted in the displacement of residents, 87 percent of whom were farming families. However, of these families, 93 percent were tenant farmers, meaning only seven percent actually owned their own land. Only one of the 835 homes had electricity, and only about three percent had an indoor water supply. (Courtesy of the Alabama Department of Archives and History.)

Relocation was hard on families. As most did not own their land, they did not receive much in the way of compensation or support for their losses. In the end, fewer than half of the relocated people moved to locations with better access to resources and housing. Seventy percent moved to land with poorer soil. (Courtesy of the Alabama Department of Archives and History.)

Completed in just three years, the construction of Wheeler Dam created a 75-mile-long reservoir covering over 67,000 acres. The first power unit commenced operation on November 9, 1936. This is the Wheeler Dam control room. (Courtesy of the Alabama Department of Archives and History.)

PHOTO BY G. W. LANDRUM

Men employed by another Depression-era program, the Civilian Conservation Corps, aided with soil erosion and forestry projects around Wheeler Dam. The TVA also planted over 17,000 acres of lespedeza (commonly known as bush clover), which belongs to the legume family, to help prevent soil erosion. (Courtesy of the University of the Lawrence County Archives, Moulton, Alabama.)

Located to the west of Wilson Dam in Tennessee is Pickwick Dam. The TVA completed construction of this dam in 1938. The building of the dam resulted in the partial flooding of Waterloo in Lauderdale County and Riverton in Colbert County. This image shows the flooding of Pickwick Reservoir. (Courtesy of the University of Alabama Museums, Tuscaloosa, Alabama.)

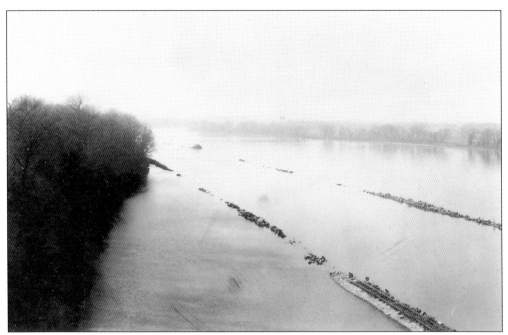

A total of 506 families had to be relocated as a result of the construction. Additionally, roads, bridges, utility lines, and even cemeteries were moved. The flooding hurt the economy of Waterloo. Property values decreased, and unemployment rose. Seen here is an old railroad line along Seven Mile Island after the flooding of Pickwick Reservoir. (Courtesy of the University of Alabama Museums, Tuscaloosa, Alabama.)

As seen in chapter one, the TVA and the WPA partnered on archeological digs at sites along the river before the flooding of Wheeler and Pickwick Reservoirs took place. Men such as these learned a great deal about the native peoples who had made the river valley their home. They also benefited from this Depression-era program, which offered them a chance to earn a living. (Courtesy of the University of Alabama Museums, Tuscaloosa, Alabama.)

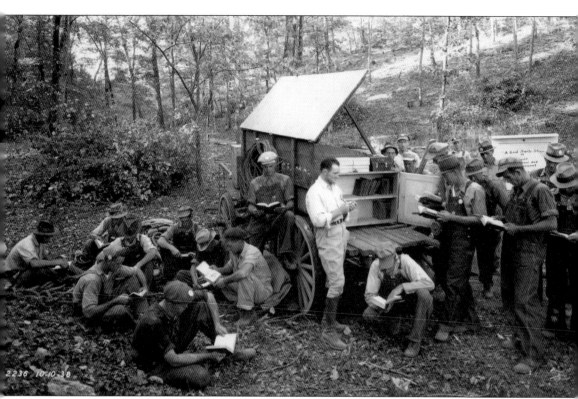

Mary Utopia Rothrock, the coordinator of libraries for the TVA, started the TVA lending library at the Norris Dam in Tennessee. Her program allowed men to check out books when they checked out their tools. The book selection included fiction, nonfiction, and children's books that men could take to their children. The program spread to other TVA sites. Eventually, permanent libraries were established in Chattanooga, Norris, and Muscle Shoals. The Muscle Shoals Library, which opened in May 1935, helped workers with job training, sponsored book review programs, and also promoted general education of the workforce (Courtesy of the University of North Alabama, Collier Library Archives and Special Collections.)

The TVA took over Nitrate Village Nos. 1 and 2 as well as Nitrate Village No. 3, which had housed workers during the construction of Wilson Dam. Because the TVA, a federal agency, owned the properties, state and local governments did not have to legally provide schools on the Muscle Shoals Reservation for the children of workers. This is the TVA School in the Nitrate Village No. 1 officers' barracks. (Courtesy of the University of North Alabama, Collier Library Archives and Special Collections.)

In 1933, the officers' barracks in Nitrate Village No. 1 was converted into a school. The curriculum of the school followed the progressive model of education, which encouraged creativity as well as cooperation over competition. (Courtesy of the University of North Alabama, Collier Library Archives and Special Collections.)

When the TVA was formed in 1933, one of the major tasks the US government charged it with was improving soil quality through the introduction of fertilizer in the Tennessee Valley region. Poor farming practices had led to the depletion of nutrients and the loss of topsoil. The TVA sought to educate farmers about the importance of crop rotation and fertilizer application. This image from Lauderdale County shows Julien Case's farmhands loading fertilizer onto a wagon in 1942. (Courtesy of the Library of Congress.)

The TVA's complex at the Wilson Dam site continued to expand during World War II. Pictured is the construction of the medical building on the TVA reservation, with the mullions, headers, and lintels in place. (Courtesy of the University of North Alabama, Collier Library Archives and Special Collections.)

This photograph taken by G.L. Bracey in 1944 shows the central plant for treating, bagging, and shipping ammonia nitrate at the Wilson Dam site. (Courtesy of the University of North Alabama, Collier Library Archives and Special Collections.)

From 1933 to the 1980s, the TVA conducted research and developed new fertilizers at the TVA reservation, including in this structure, the TVA Fertilizer Plant Office Building. The TVA partnered with educational institutions, including Auburn University and the University of Tennessee. It did not, however, work with African American agricultural colleges like Alabama A&M. (Courtesy of the University of North Alabama, Collier Library Archives and Special Collections.)

During World War II, the TVA produced materials for explosives and other materials for the war effort. This image of the TVA Fertilizer Plant shows the patriotic sentiment on the TVA reservation. One sign reads "1 Down (Italy) 2 To Go Hitler-Tojo Come On Gang Let's Help Get 'Em." The other sign encouraged the men to use 15 percent of their salary to buy war bonds. (Courtesy of the University of North Alabama, Collier Library Archives and Special Collections.)

A TVA employee is fitting a valve for a gas compressor in the TVA's synthetic ammonia plant during World War II. This plant opened in August 1942. The plant output was 181 tons of nitrates per day. The TVA also produced synthetic rubber for the war effort. (Courtesy of the Library of Congress.)

When the TVA came to northwest Alabama, it promised equal opportunity to all residents, regardless of race. TVA's Employee Relationship Policy read, "No discrimination in occupational classification or in rates of pay shall be made on the basis of sex or race." However, the men pictured here, Paul L. Imes, Samuel C. Watkins, and George W. Richardson, who worked as laboratory technicians, were the exception rather than the rule. (Courtesy of the Library of Congress.)

The TVA used a quota system to determine how many African Americans to hire in Muscle Shoals. African Americans made up 10 percent of the population in the Tennessee Valley and, on average, 10 percent of the workforce. However, most African Americans worked in semiskilled or unskilled positions. They continued to live in segregated communities on the Muscle Shoals Reservation. (Courtesy of the Library of Congress.)

After World War II, industrial growth increased rapidly across the TVA region. Soon, demand for electricity exceeded what the TVA could produce with the hydroelectric dams it controlled. New sources of power had to be identified and secured. The largest of these sources in the 1950s and 1960s was coal. Coal came to dominate TVA energy production, accounting for 80 percent of all energy generated by the mid-1960s. The US Army Corps of Engineers had built a coal-powered steam plant to generate electricity for the nitrate plants before Wilson Dam was completed. In 1968, the TVA demolished this plant. These aerial views from after World War II show the postwar growth across the Muscle Shoals Reservation. (Both, courtesy of the University of North Alabama, Collier Library Archives and Special Collections.)

In 1951, the TVA began construction on the Colbert Fossil Plant, shown here. The facility opened in January 1955, when coal was still plentiful across the Appalachian region. As coal supplies dwindled and concern over pollution grew, the TVA increasingly turned to nuclear power. The Colbert Fossil Plant closed in 2016 and demolition started in 2017. (Courtesy of the Alabama Department of Archives and History.)

Northwest Alabama benefitted from postwar industrial growth. Companies, including Reynolds Aluminum and the Ford Motor Company, chose to locate their operations near Muscle Shoals. Companies that existed before the war also grew, including the Ingalls Ship Building Company and Decatur Iron and Steel Company. This image shows the TVA Chemical Engineering building in Muscle Shoals. (Courtesy of the Library of Congress.)

As water traffic grew on the river because of industrial growth, updates to bridges took place. These images from 1962 show the 406-foot lift span being moved into position on the railroad bridge that moved rail traffic across the river from Sheffield to Florence. Today, while the railroad bridge itself remains and is accessible to pedestrians from the TVA reservation, the lift portion is no longer in place. (Both, courtesy of the University of North Alabama, Collier Library Archives and Special Collections.)

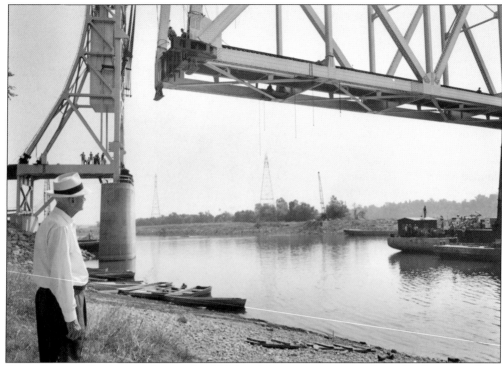

Capt. Conway Graden watches as the 406-foot lift span is put into place. Graden was a boat captain on the Tennessee River. (Courtesy of the University of North Alabama, Collier Library Archives and Special Collections.)

On May 18, 1963, Pres. John F. Kennedy traveled to Muscle Shoals to celebrate the 30th anniversary of the formation of the TVA. He traveled with White House press secretary Pierre Salinger, chairman of the TVA Board of Directors Aubrey J. Wagner, Kennedy family friend Kirk LeMoyne Billings, and White House Secret Service agents Bill Greer, Dick Johnsen, Sam Sulliman, and Roy Kellerman, among others. (Courtesy of the Library of Congress.)

Alabama governor George Wallace joined President Kennedy in Muscle Shoals. Tensions over the civil rights movement were high in Alabama. It had been little more than a month since Birmingham police commissioner Eugene "Bull" Connor had shocked the world when he ordered his officers to use fire hoses, police dogs, and clubs to try to break up protestors, many of whom were children. A week before Kennedy's trip, the A.G. Gaston Motel in Birmingham, popular with civil rights leaders, had been bombed. Kennedy had taken preliminary steps toward federalizing the Alabama National Guard, to which Wallace responded by calling Kennedy a "military dictator." Just a few months after this meeting on the TVA reservation, Wallace would famously stand in a doorway at the University of Alabama in an attempt to prevent two African American students from registering for classes. In response, Kennedy did federalize the Alabama National Guard troops to force the integration of the university. (Both, courtesy of the Library of Congress.)

During his speech, Kennedy highlighted the importance of the Tennessee River Valley in the overall health of the nation, stating, "This great country of ours has been developed because people working together made it possible to develop this valley, congressmen and senators from the Northeast United States who have voted for it, men from this part of the country who have helped develop the West. By working together, we have recognized that a rising tide lifts all the boats, and this valley will not be prosperous unless other sections of the country are rich, nor will other sections of the country be rich unless the valley is prosperous. That is the lesson of the last 30 years." (Courtesy of the Library Congress.)

The TVA started the National Fertilizer Development Center (NFDC) in 1963. The center helped developing countries determine what fertilizers to use, what crops worked best for their farmers, and how to market and sell the resulting products. In 1974, the International Fertilizer Development Corporation (IFDC) also began to operate on the TVA reservation. Pictured here is the IFDC headquarters on the Muscle Shoals Reservation. (Courtesy of the International Fertilizer Development Corporation.)

The IFDC was organized as an international public nonprofit. Its mission centered around collecting and sharing information about fertilizer, and training farmers in developing countries in its use. It also sought to reduce hunger and poverty through sustainable agricultural practices. Pictured is a greenhouse at IFDC's headquarters. (Courtesy of the International Fertilizer Development Corporation.)

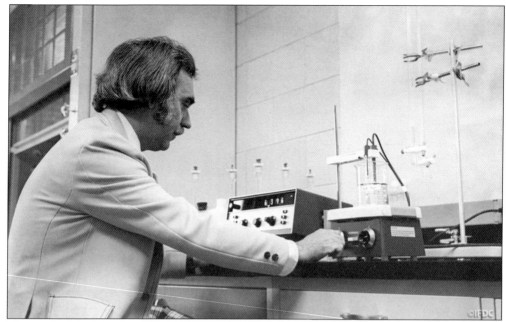

The work of the NFDC and the IFDC sparked the Green Revolution. New strains of high yield grains adapted for the conditions found in developing countries, combined with new fertilizers, helped increase agricultural output and raised living standards. Owen Livingston, who served in various capacities with IFDC including Fertilizer Technology Division director, is seen here at IFDC headquarters. (Courtesy of the International Fertilizer Development Corporation.)

The work of the NFDC and IFDC resulted in the development of approximately 75 percent of the fertilizers used around the world today. Most of these fertilizers were developed between the 1950s and late 1970s. This image shows farmers in a rice paddy with IFDC staff. (Courtesy of the International Fertilizer Development Corporation.)

The Muscle Shoals Reservation covered 2,640 acres on the south side of the Tennessee River. At its peak, approximately 2,800 people worked on the reservation. Today, that number is much smaller, numbering only in the hundreds. This image shows the No. 6 Acid Plant. (Courtesy of the International Fertilizer Development Corporation.)

Today, many of the buildings across the reservation stand empty or have been demolished. The TVA began demolition of unused buildings on the reservation in 1983. One of the largest problems the TVA has faced since the 1980s is dealing with pollution on the reservation. This is the Cyanamid Oven Building. (Courtesy of the Library of Congress.)

Parts of the reservation are contaminated from chemicals used in the development of the different materials the TVA produced. Other companies in the region, including the Ford Motor Company and Occidental Chemical, also had to address serious issues related to pollution. This is an interior view of the Cyanamid Oven Building on the Muscle Shoals Reservation. (Courtesy of the Library of Congress.)

In 2011, the TVA released a statement on the environmental condition of surplus reservation land it wished to sell. Some of the land on the reservation has to remain under the TVA's control because of pollution problems. Pictured are the wash and locker houses on the TVA reservation after use of the buildings ceased. (Courtesy of the University of North Alabama, Collier Library Archives and Special Collections.)

On November 15, 2012, the TVA Board of Directors made the decision to auction off 1,000 acres of reservation land. Much of the land remains for sale today. This is an interior view of the wash and locker houses on the TVA reservation. (Courtesy of the University of North Alabama, Collier Library Archives and Special Collections.)

Today, the TVA's headquarters is in Knoxville, Tennessee. The TVA continues to operate dams and hydroelectric facilities in northwest Alabama. Additionally, it also operates the Brown's Ferry Nuclear Plant near Athens, Georgia, which is the second-largest power generating plant in the nation. This is the TVA Chemical Engineering building. (Courtesy of the University of North Alabama, Collier Library Archives and Special Collections.)

Nitrate Building No. 4 was torn down in 1984. The TVA demolished almost 40 percent of the buildings on the Muscle Shoals Reservation. By 1998, the development of fertilizer on the reservation had almost completely ceased. (Courtesy of the University of North Alabama, Collier Library Archives and Special Collections.)

Over its eight decades of operation in northwest Alabama, the TVA has made a dramatic difference in the lives of residents. In bringing cheap electricity to the region, the TVA helped facilitate economic and industrial growth. Pictured is a substation on the reservation. (Courtesy of the University of North Alabama, Collier Library Archives and Special Collections.)

At times, the TVA has faced heavy criticism. Residents who had to be relocated for the construction of the dams often disliked and distrusted the TVA. Others have criticized it as an example of federal overreach. This image shows a sign about an important TVA rule in a laundry building at US Nitrate Plant No. 2. (Courtesy of the University of North Alabama, Collier Library Archives and Special Collections.)

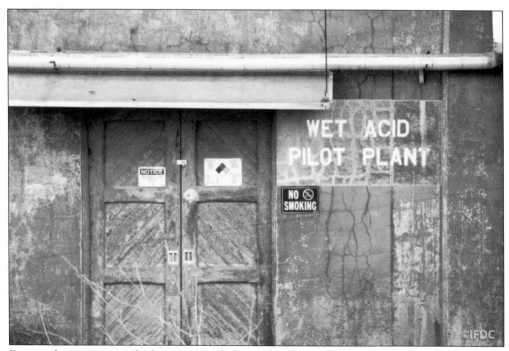

Despite this criticism and other issues, including pollution, the TVA remains a popular institution on the cultural landscape of northwest Alabama. Over 1,400 people work at Brown's Ferry Nuclear Plant, and hundreds still work on the Muscle Shoals Reservation. (Courtesy of the International Fertilizer Development Corporation.)

Other people benefit from the TVA's presence in different ways. Between 2013 and 2015, the TVA improved hiking, biking, and walking trails across the Muscle Shoals Reservation. Fishermen make their way down to the river banks or launch their boats near the base of Wilson Dam. Civilian Conservation Corps–constructed picnic facilities are often busy on weekends with family gatherings and celebrations. Jack O'Lantern Farms partially operates out of the old TVA greenhouses, growing food for local restaurants and residents. While the heyday of the TVA on the Muscle Shoals Reservation has ended, the reservation is still full of life. (Courtesy of the University of North Alabama, Collier Library Archives and Special Collections.)

# Five

# THE MUSCLE SHOALS NATIONAL HERITAGE AREA AND THE TENNESSEE RIVER

While this map, which dates from the Civil War, does not show the entire Muscle Shoals National Heritage Area (MSNHA), it does give an idea of the large numbers of creeks and rivers in northwest Alabama that feed into the Tennessee River. One of the missions of the MSNHA is to help protect and preserve this important resource for the future. The MSNHA helps to sponsor projects to improve recreational access to the water and works with community organizations to clean waterways. The MSNHA also develops educational resources for teachers in the community to help educate the next generation of river keepers. The MSNHA has partnered with organizations, including the Alabama Scenic River Trail, to help develop programs to train people interested in operating adventure service businesses on the waterways. These waterways shape the lives of people in the MSNHA, and ensuring their continued health is a vital part of who Muscle Shoals people are. (Courtesy of the Alabama Department of Archives and History.)

One of the most important historical figures in northwest Alabama is Gen. Joe Wheeler, who was one of the few former Confederate officers to serve with the US Army during the Spanish-American War. At one time, Wheeler Plantation covered over 18,000 acres. Laborers are seen here working on the plantation. The TVA acquired some of the land when it constructed Wheeler Dam, which is named after General Wheeler. (Courtesy of the University of North Alabama, Collier Library Archives and Special Collections.)

The Anderson Gristmill is located on Anderson Creek near the border between Lauderdale and Limestone Counties. Starting in the early 19th century, settlers built mills along the creeks that feed into the Elk and Tennessee Rivers. (Courtesy of the University of North Alabama, Collier Library Archives and Special Collections.)

This is the Perry Dam on Cypress Creek in Lauderdale County. Today, the creek is undammed and is very popular with kayakers. (Courtesy of the Alabama Department of Archives and History.)

The creek is also popular with fishermen. Smallmouth bass, rock bass, gar, bluegill, sunfish, and perch make the creek their home. Osprey, blue herons, river otters, turtles, and many other species of birds and animals also reside on or in Cypress Creek. (Courtesy of the Alabama Department of Archives and History.)

People have made the river and its banks their home in many different ways since they arrived over 10,000 years ago. This 20th-century family lived on a houseboat on the river. During the construction of the Muscle Shoals Canal at the end of the 19th century, some laborers lived in houseboats. Today, houseboats are still an occasional sight on the river. (Courtesy of the University of North Alabama, Collier Library Archives and Special Collections.)

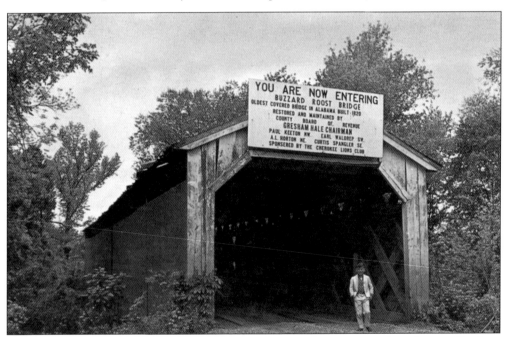

At one time, the Muscle Shoals National Heritage Area was home to a number of covered bridges. This one was located at Buzzards Roost in Colbert County and burned in the 1970s. Today, the site is part of the Natchez Trace Parkway System. (Courtesy of the University of North Alabama, Collier Library Archives and Special Collections.)

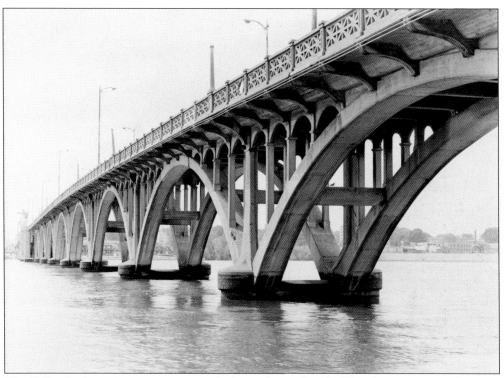

The Keller Bridge in Decatur was named after Helen Keller's half-brother Simpson Keller, who served as the first highway engineer for Alabama. Completed in 1928, the bridge was 2,077 feet long. It had a movable bascule, one of two in the entire state. The bridge was demolished in 1998. (Courtesy of the Library of Congress.)

During World War II, Ingalls Shipbuilding Company employed 1,500 workers. It built barges and small freighters for the war effort. Because of the improved navigability of the river, ships could be built in the shoals and then sent where they were needed. Here, an Ingalls Shipbuilding Company ship fitter is pictured with his helper. (Courtesy of the Library of Congress.)

Legends abound of enormous catfish, some the size of a Volkswagen Beetle, that live at the base of the dam. In a 2010 story in the *Times Daily*, the local newspaper in northwest Alabama, retired TVA employee John P. Blackwell said that fishermen have caught 100-pound catfish, but none as large as Volkswagens! (Courtesy of the University of North Alabama, Collier Library Archives and Special Collections.)

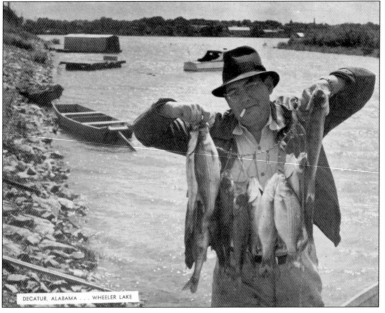

In 1996, a fisherman caught a 111-pound blue catfish in Wheeler Lake, which set the state record. Pickwick Lake is considered the best lake for bass fishing in the entire state. People come from all over the country to fish in the region. (Courtesy of the University of North Alabama, Collier Library Archives and Special Collections.)

WHEELER LAKE . . . FISHING SCENE JUST BELOW THE DAM

The University of North Alabama is home to a nationally ranked bass fishing team, which allows students to continue the rich tradition of fishing on Wilson, Wheeler, and Pickwick Lakes. (Courtesy of the University of North Alabama, Collier Library Archives and Special Collections.)

On nice days like the one in this photograph, which shows members of the Hall family enjoying the river, one can find kayakers, canoers, fishermen, and pleasure boaters out on all the lakes in the Muscle Shoals National Heritage Area. The Bear Creek Lakes, located south of the Tennessee River in Franklin County, are another popular TVA–managed system of lakes. (Courtesy of the Library of Congress.)

**Greetings from FLORENCE, Ala.**

It is impossible to overestimate the significance of the Tennessee River and its tributaries to recreational life in the region. The economies benefit greatly from the fishermen who come to fish these waters. Ensuring the safety of these waters from pollution in order to protect one of the area's greatest resources is essential. Organizations, including the Tennessee Riverkeeper, work to educate the public about keeping the water clean and the fish healthy. (Courtesy of the University of North Alabama, Collier Library Archives and Special Collections.)

Despite the control the TVA gained over the Tennessee River through the construction of dams, floods still remain a distinct possibility. From March 14 to March 18, 1973, a cold front sat in a stationary position over much of the Southeast. While Chattanooga was hit the hardest by the floods, communities in all of the counties in the area also suffered massive amounts of damage. This image shows the flood waters in Tuscumbia. (Courtesy of the University of North Alabama, Collier Library Archives and Special Collections.)

To the natives who lived on its shores, to the first white settlers who built mills along its tributaries, to the enslaved Africans forced to work in cotton fields along its banks, to the men who fought in battles and skirmishes along the river during the Civil War, to the people who built the canals and dams, and to those who changed lives through introducing electricity to the region, the river has had an enormous impact on the residents of northwest Alabama. Today, the Muscle Shoals National Heritage Area works with communities across the region to preserve and protect this significant resource and the stories that trace their roots back to the river. As retired MSNHA director Judy Sizemore is fond of saying, "You can tie everything back to the river!" (Courtesy of the Library of Congress.)

# BIBLIOGRAPHY

Atkinson, James. *Splendid Land, Splendid People: The Chickasaw Indians to Removal.* Tuscaloosa, AL: University of Alabama Press, 2004.

Billington, David, Donald Jackson, and Martin Melosi. *The History of Large Federal Dams: Planning, Design, and Construction in the Era of Big Dams.* Denver, CO: US Department of the Interior, 2005.

Callahan, North. *TVA: Bridge Over Troubled Waters.* New York, NY: A.S. Barnes and Co., 1980.

Dobravolsky, Don. "The Tuscumbia, Courtland & Decatur Railroad." *The Historic Huntsville Quarterly* Vol. XXX1, No. 1. Spring 1995.

Downs, Matthew. *Transforming the South: Federal Development in the Tennessee Valley, 1915–1960.* Baton Rouge, LA: Louisiana State Press, 2014.

Goings, Henry. *Rambles from a Runaway from Southern Slavery.* Charlottesville, VA: University of Virginia Press, 2012.

Hager, Thomas. *Feeding a Hungry World: IFDC's First Forty Years.* Muscle Shoals, AL: International Fertilizer Development Corporation, 2014.

Hargrove, Erwin, and Paul Conkin. *TVA: Fifty Years of Grass Roots Bureaucracy.* Chicago, IL: University of Illinois Press, 1983.

Hubbard, Preston. *Origins of the TVA.* Nashville, TN: Vanderbilt University Press, 1961.

Johnson, Kenneth. *Life in the Muscle Shoals.* Killen, AL: Bluewater Publications, 2013.

Lowitt, Richard. *George Norris: The Persistence of a Progressive, 1913–1933.* Urbana, IL: University of Illinois Press, 1971.

Nelson, Lewis. *History of the U.S. Fertilizer Industry.* Muscle Shoals, AL: Tennessee Valley Authority, 1990.

Neuse, Stephen. *David Lilienthal: The Journey of an American Liberal.* Knoxville, TN: University of Tennessee Press, 1997.

Shaffer, Daniel. "War Mobilization in Muscle Shoals, Alabama, 1917–1918." The *Alabama Review* Vol. 39, No. 2. 1986.

*The Tennessee River Navigation System: History, Development, Operation, Technical Report 25.* Knoxville, TN: Tennessee Valley Authority, 1964.

Walthall, John. *Prehistoric Indians of the Southeast: Archeology of Alabama and the Middle South.* Tuscaloosa, AL: University of Alabama Press, 1990.

Weingardt, Richard. "George Washington Goethals." *Leadership & Management in Engineering* Vol. 7, No. 1. January 2007.

Winn, Joshua Nicholas. *Muscle Shoals Canal: Life with Canalers.* Huntsville, AL: Strode Publishers, 1978.

Wright, Leslie. "Henry Ford and Muscle Shoals." *Alabama Review* Vol. 14, No. 3. July 1961.

# DISCOVER THOUSANDS OF LOCAL HISTORY BOOKS FEATURING MILLIONS OF VINTAGE IMAGES

Arcadia Publishing, the leading local history publisher in the United States, is committed to making history accessible and meaningful through publishing books that celebrate and preserve the heritage of America's people and places.

## Find more books like this at
## www.arcadiapublishing.com

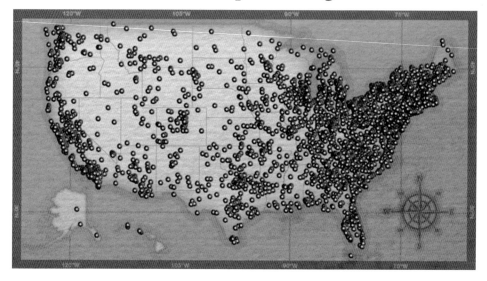

Search for your hometown history, your old stomping grounds, and even your favorite sports team.

Consistent with our mission to preserve history on a local level, this book was printed in South Carolina on American-made paper and manufactured entirely in the United States. Products carrying the accredited Forest Stewardship Council (FSC) label are printed on 100 percent FSC-certified paper.

MADE IN THE USA